Kids These Days

James "The Ace" Harrod

copyright © 2012 James Harrod

ISBN 978-1-105-69671-8

Thank you friends, family, Stephen Shingler and Steve Martin.

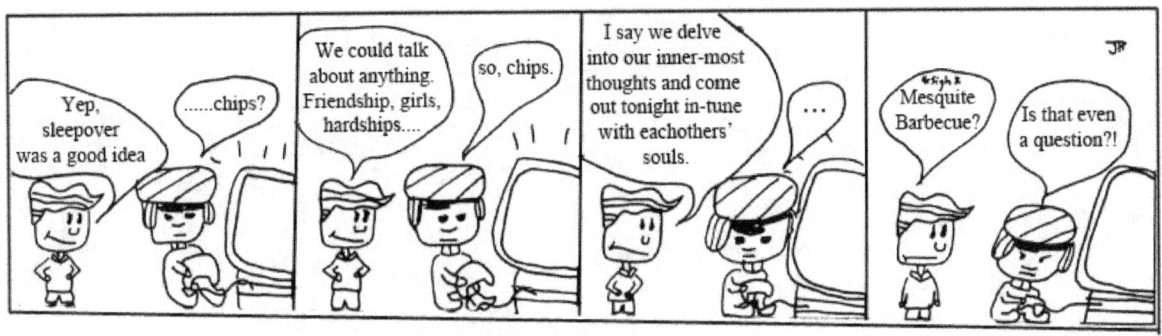
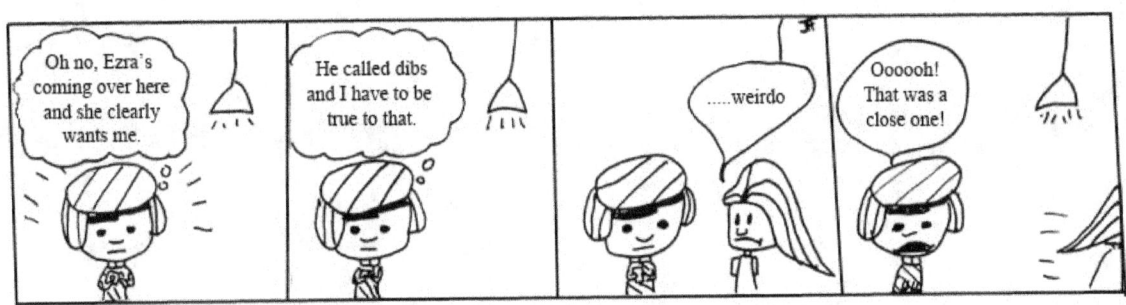

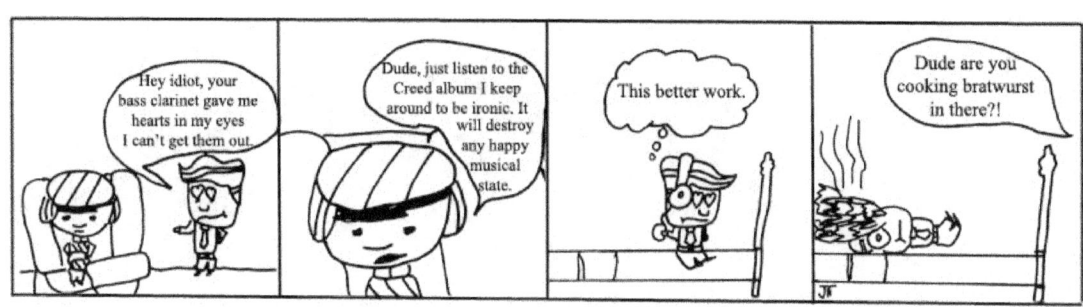

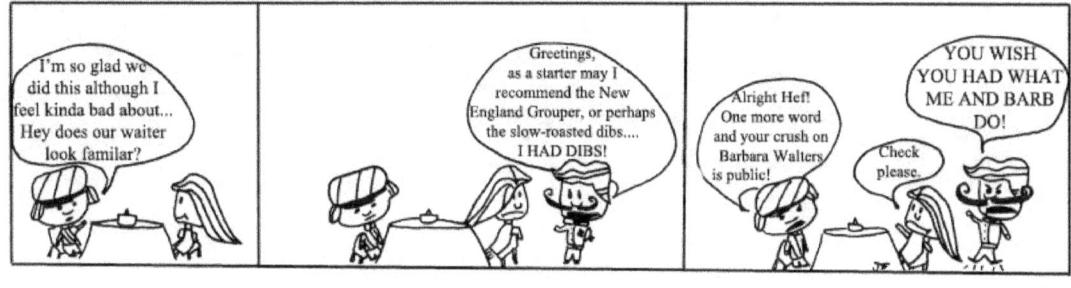

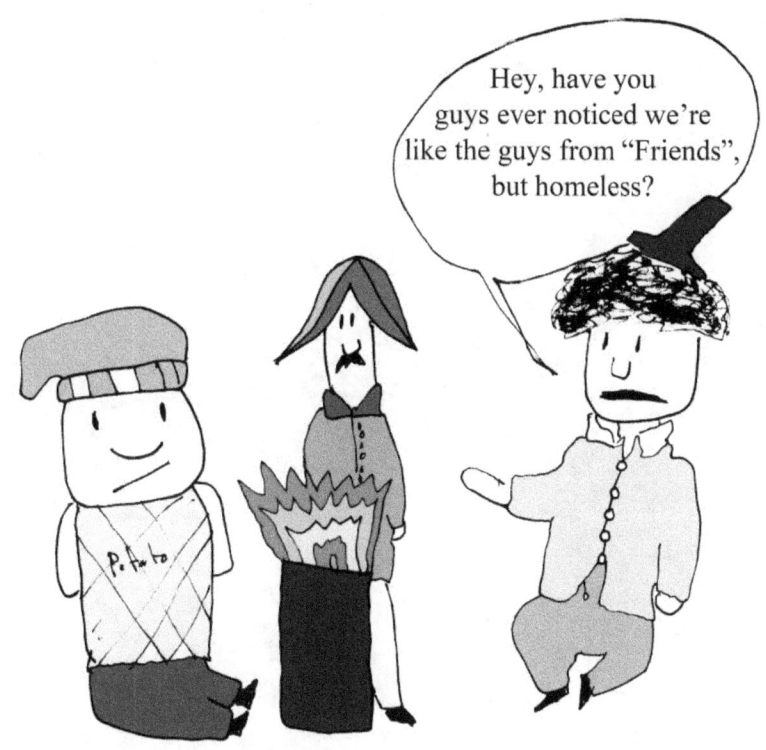

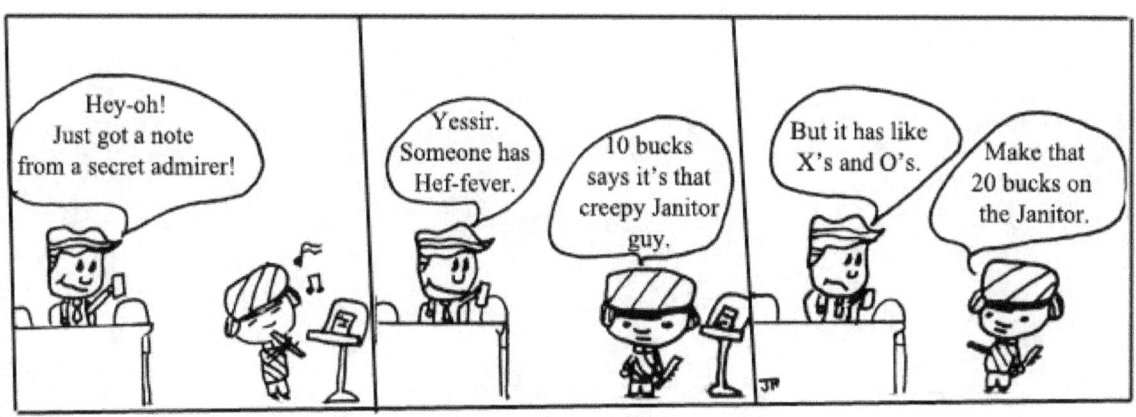

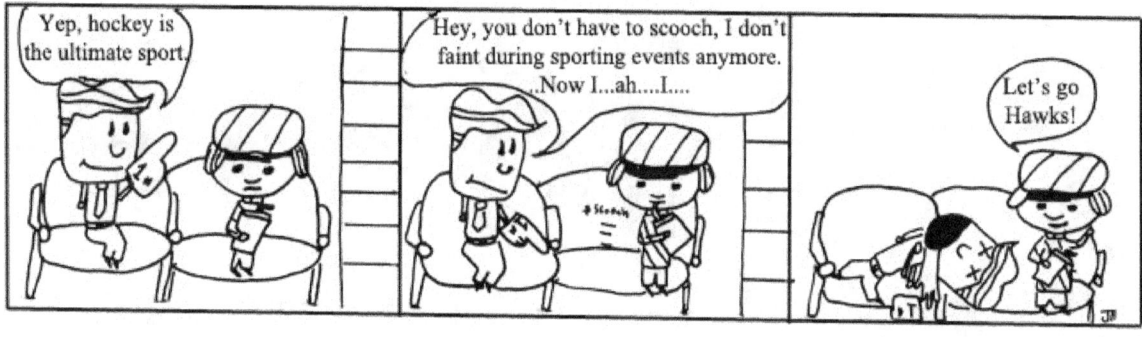

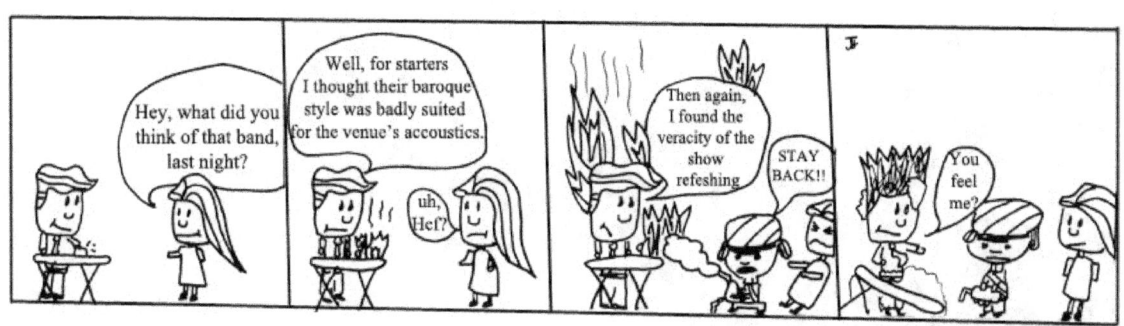
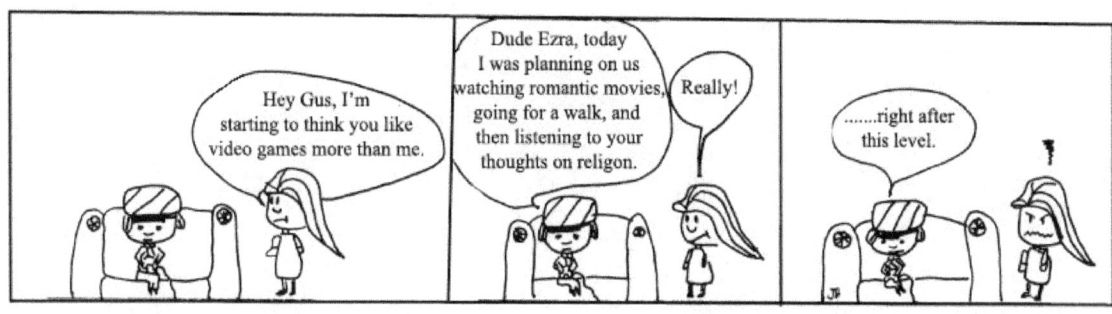

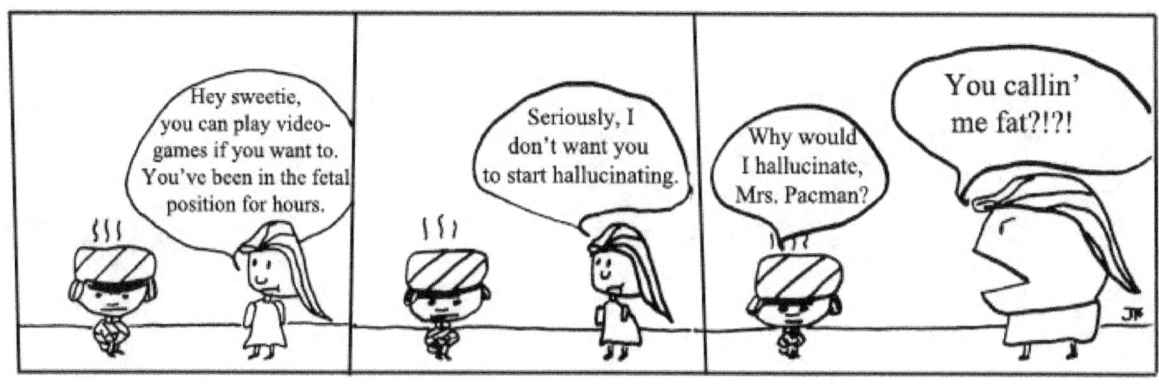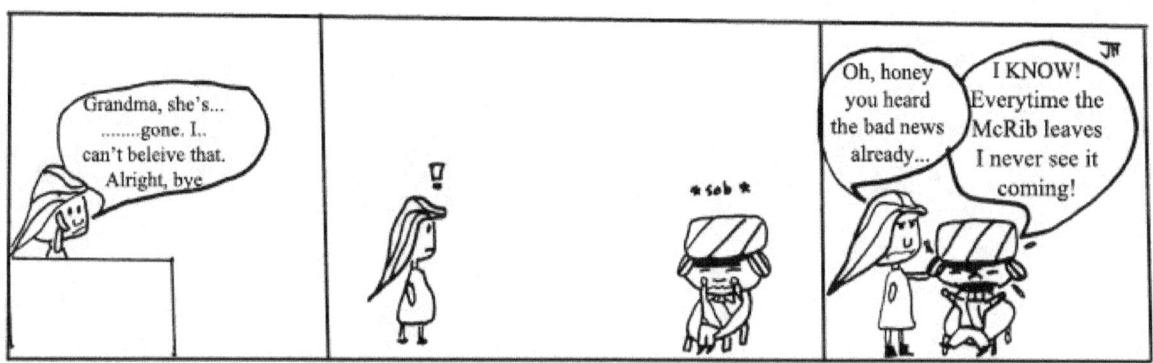

Are you guys really all that happy?

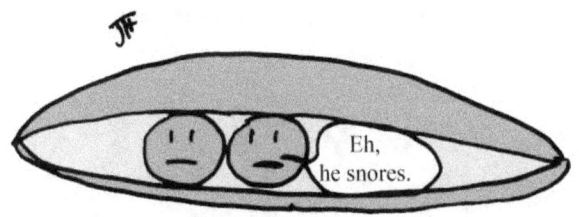

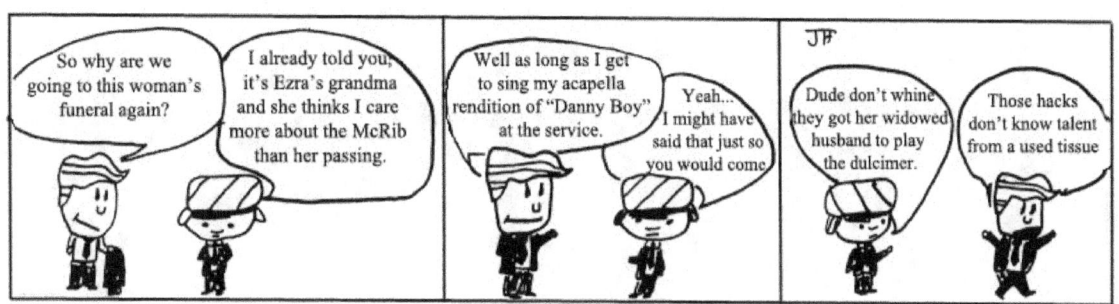
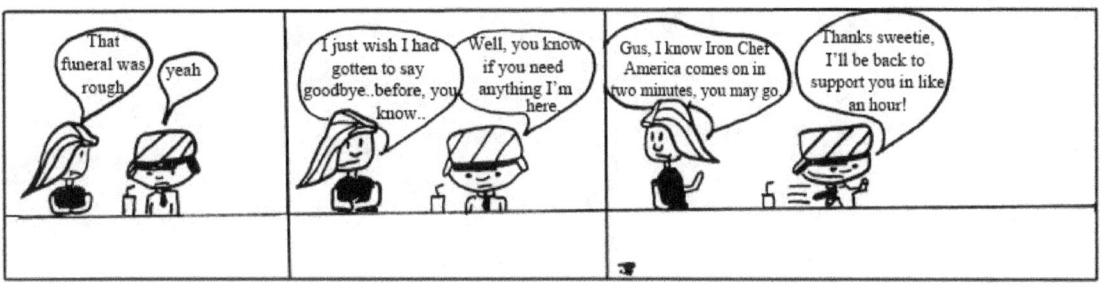

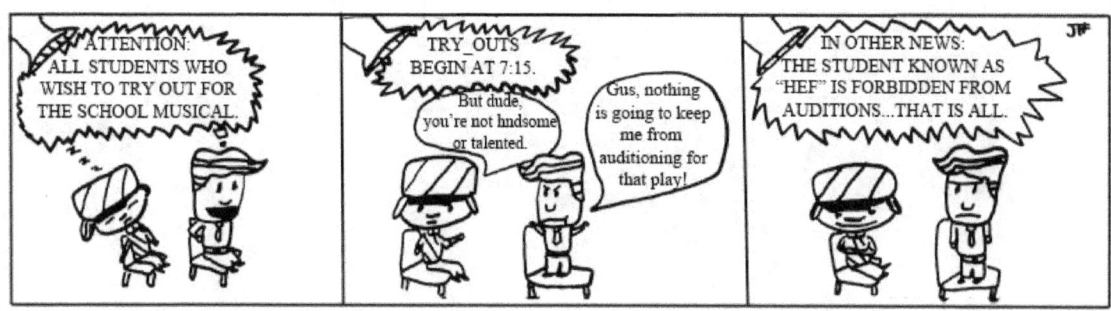

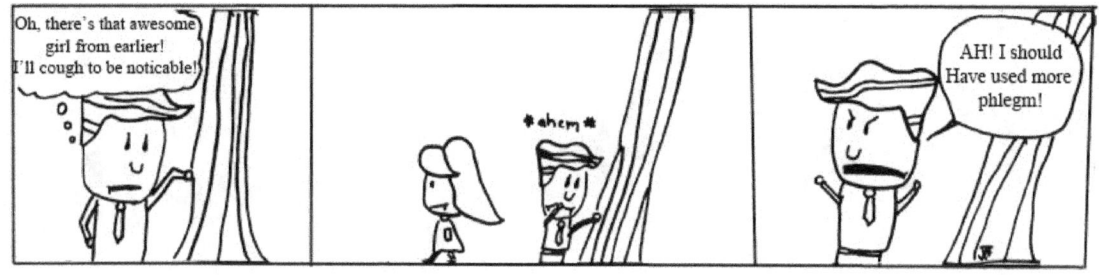

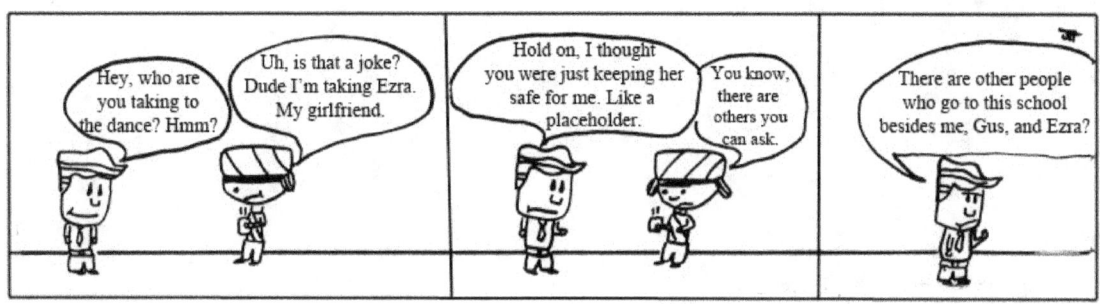

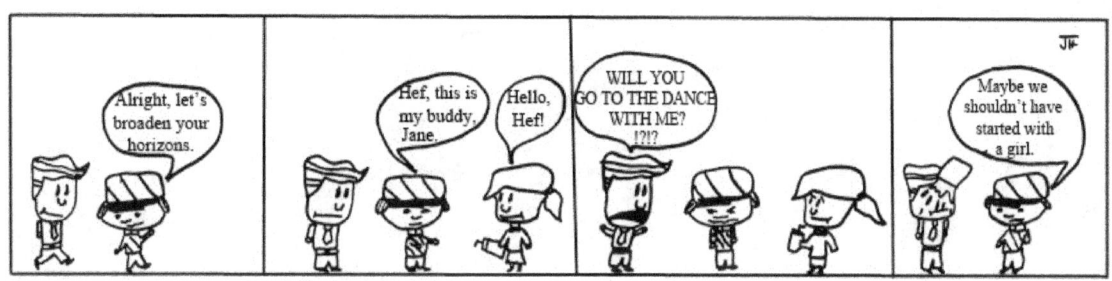

Self-Help

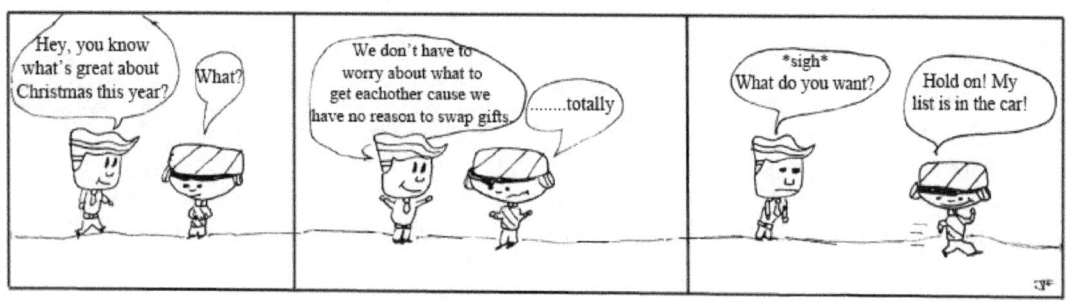

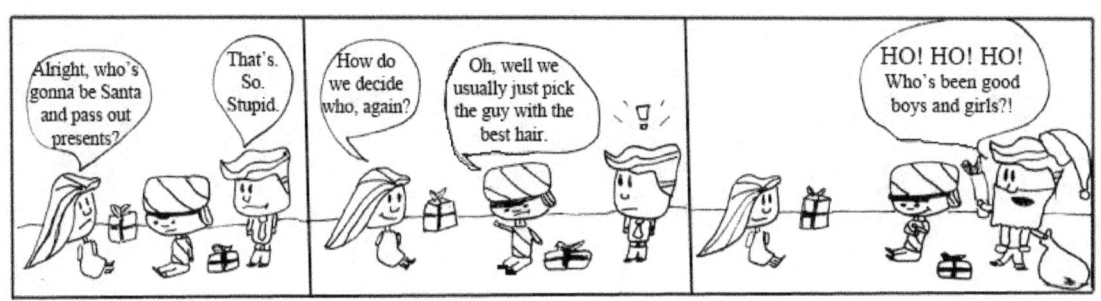

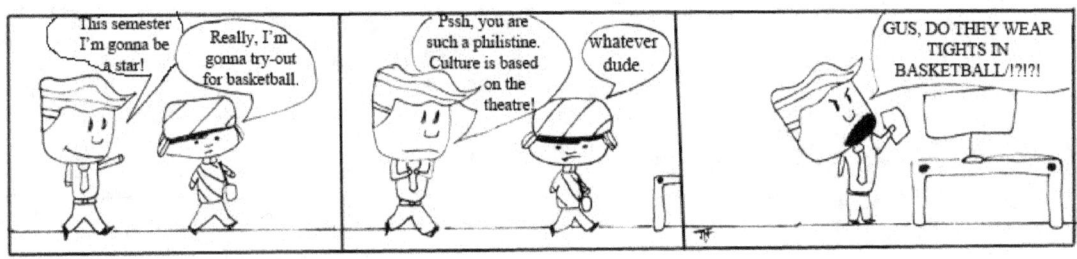

Reality TV Show in Jersey

Reality TV Show in North Carolina

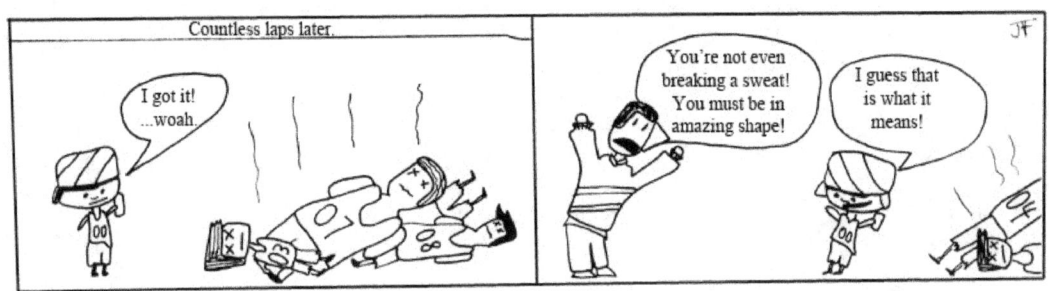

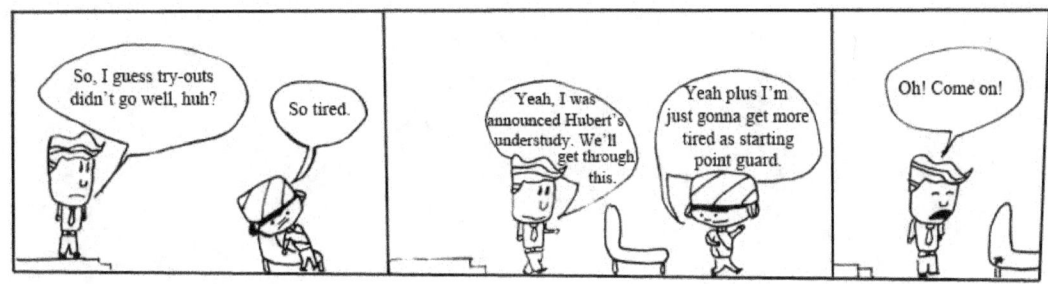

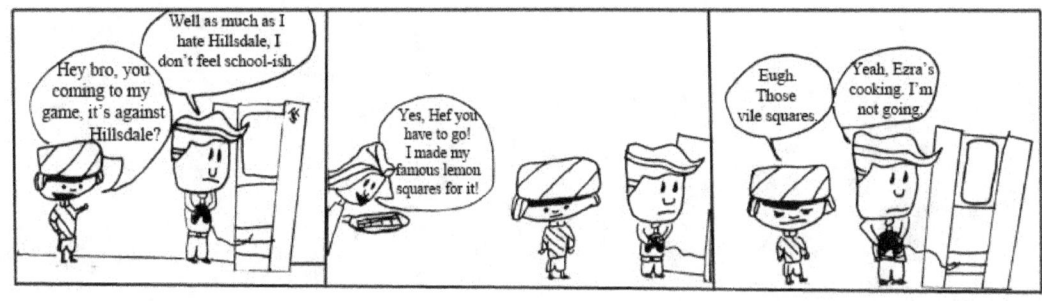

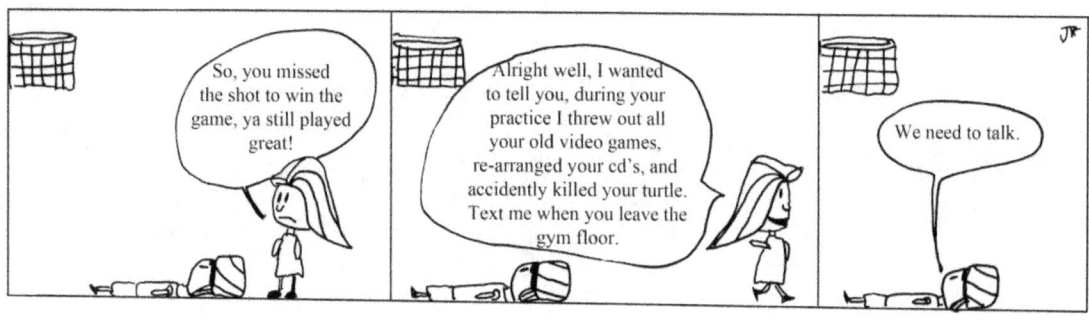

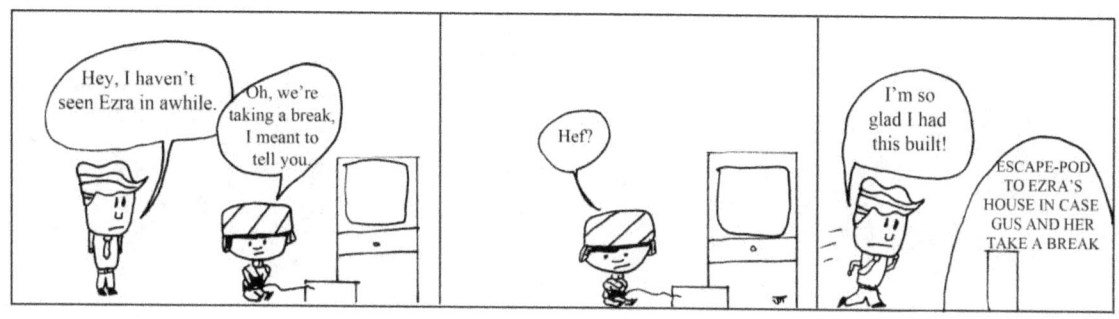

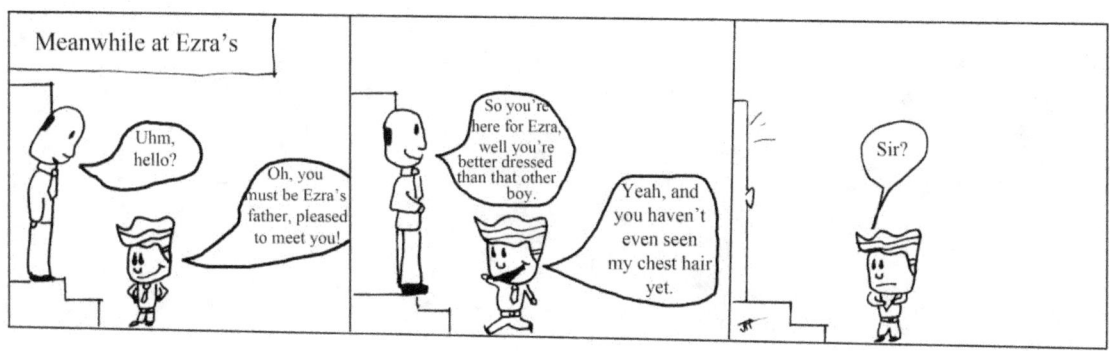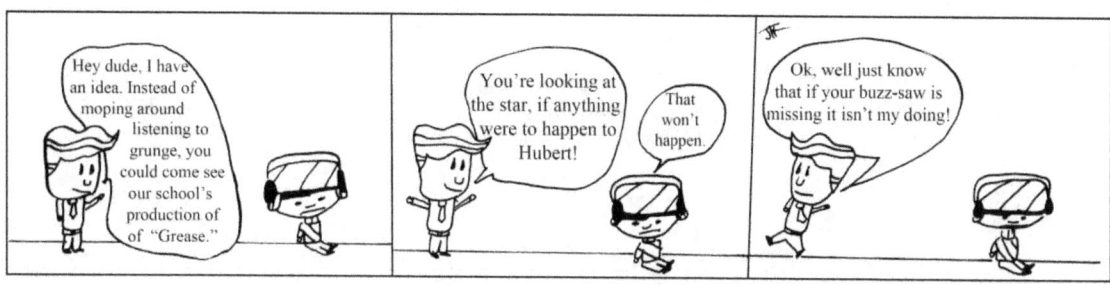

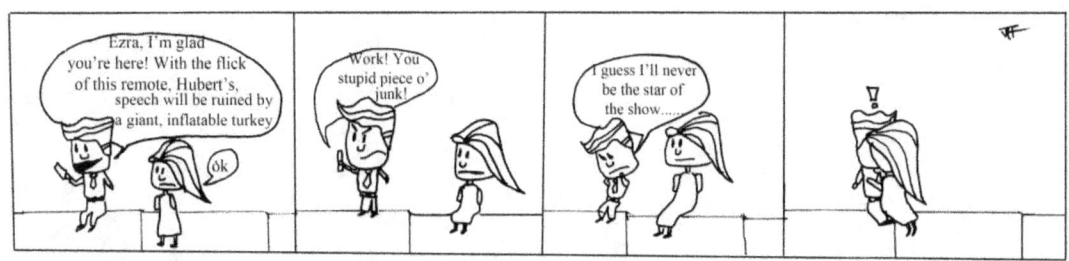
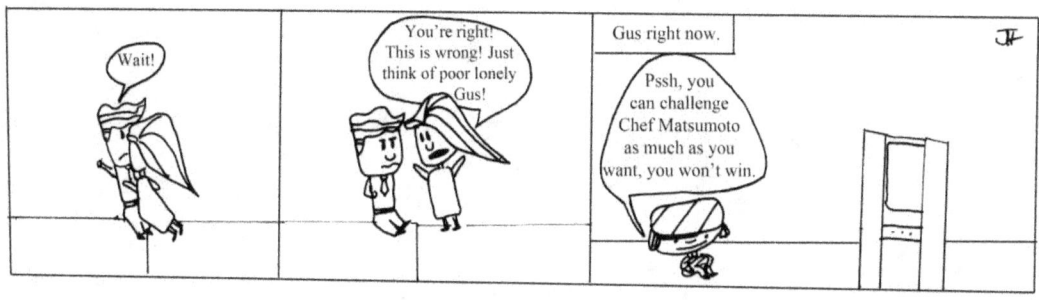

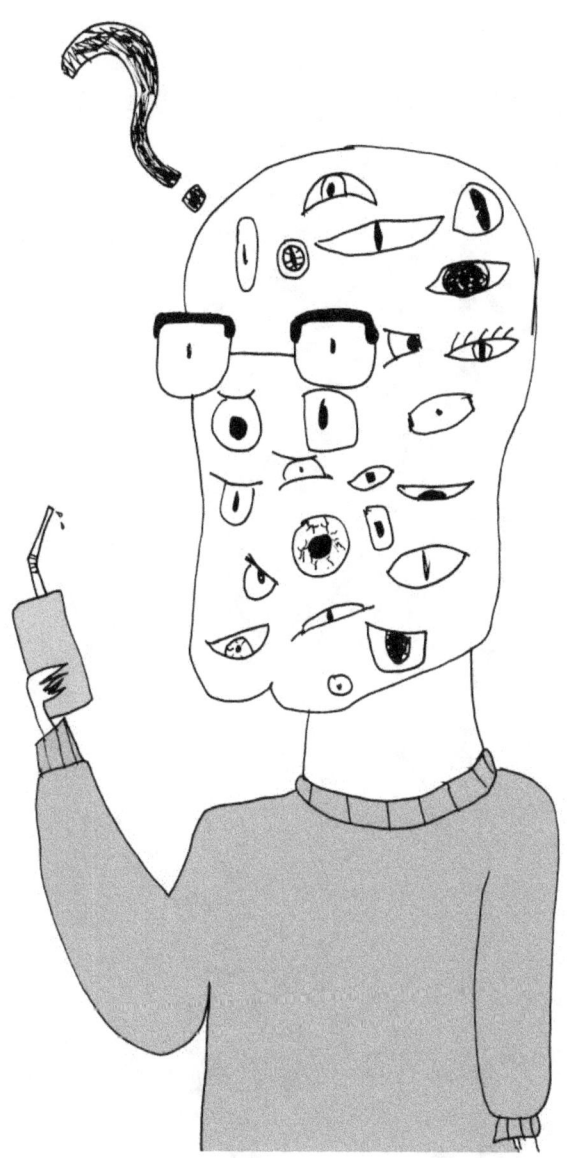

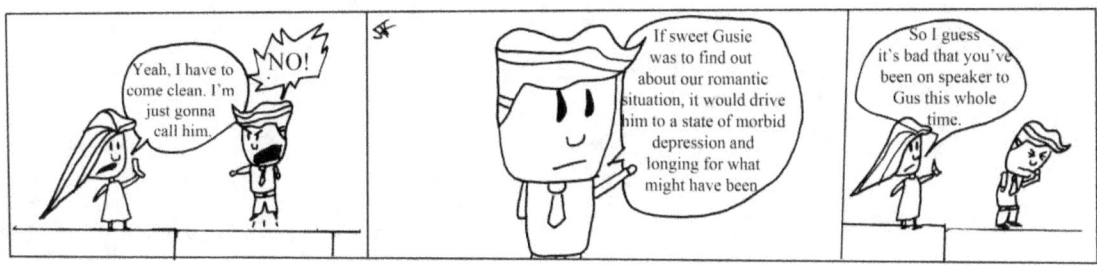
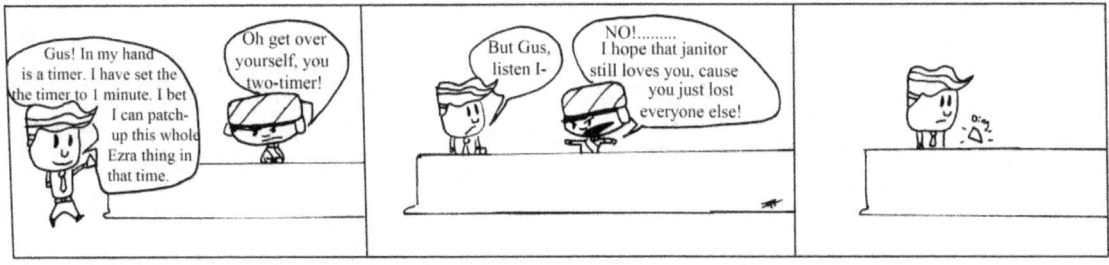

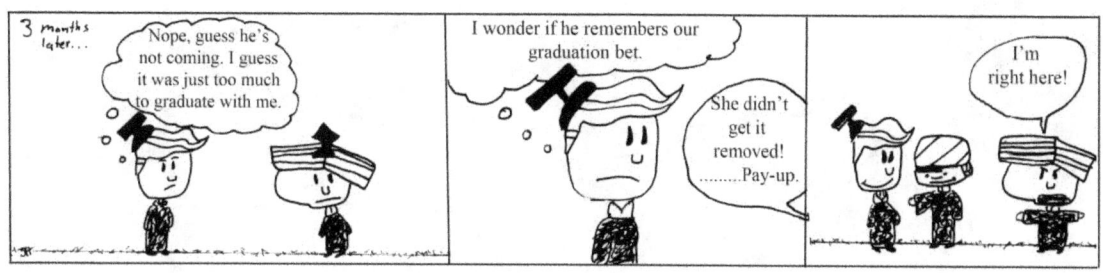

www.ingramcontent.com/pod-product-compliance
Lightning Source LLC
Chambersburg PA
CBHW080823170526
45158CB00009B/2508